PAUL BRYN DAVIES has been a professional artist and illustrator all his working life. In addition to producing countless magazine illustrations, Paul has worked as an advertising illustrator, has had his work published as posters, greeting cards and fine art prints. Fantasy has been the dominant theme in Paul's career.

Paul has also produced over 150 book jackets for some of the world's leading authors, including such luminaries as Christopher Pike, Lyall Watson, Robert E. Vardeman and Stephen King. Paul has designed and illustrated some thirteen book jackets for Stephen King including the author's first ever Number one European best seller. Paul lives in Kent with his wife and two daughters.

The Search Press Fantasy Art Series

Painting Dragons in Watercolour
Paul Bryn Davies
1 84448 151 4
978-1-84448-151-4

Painting Angels in Watercolour
Elaine Hamer
1 84448 147 6
978-1-84448-147-7

Painting Fairies in Watercolour
Paul Bryn Davies
1 84448 166 2
978-1-84448-166-8

Painting Unicorns in Watercolour
Rebecca Balchin
1 84448 165 4
978-1-84448-165-1

Painting Fairies
in
Watercolour

PAUL BRYN DAVIES

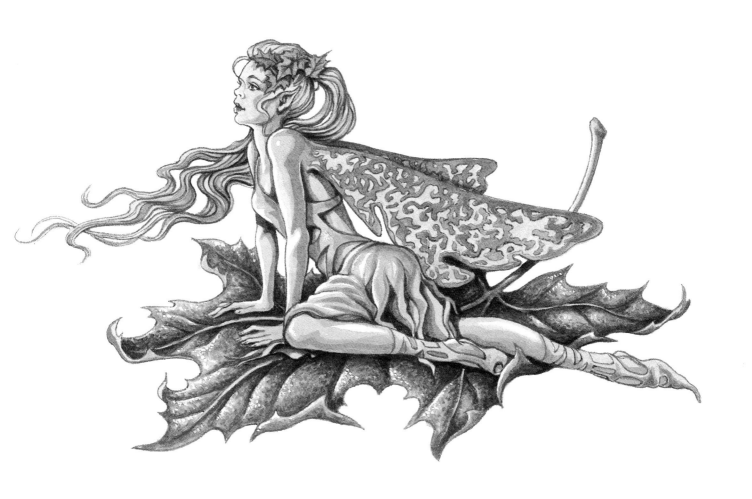

SEARCH PRESS

First published in Great Britain 2007

Search Press Limited
Wellwood, North Farm Road,
Tunbridge Wells, Kent TN2 3DR

Text copyright © Paul Bryn Davies 2007

Photographs by Steve Crispe, Search Press Studios and by
Roddy Paine Photographic Studios

Photographs and design copyright © Search Press Ltd, 2007

ISBN-10: 1-84448-166-2

ISBN-13: 978-1-84448-166-8

The Publishers and author can accept no responsibility for
any consequences arising from the information, advice or
instructions given in this publication.

The Publishers would like to thank Winsor & Newton for
supplying some of the materials used in this book.

Suppliers
If you have difficulty in obtaining any of the materials or
equipment mentioned in this book, then please visit the
Search Press website for details of suppliers:
www.searchpress.com

Publisher's note
All the step-by-step photographs in this book feature the
author, Paul Bryn Davies, demonstrating his watercolour
painting techniques. No models have been used.

There are references to animal hair brushes in this book. It
is the Publisher's custom to recommend synthetic materials
as substitutes for animal products wherever possible. There
is now a large range of brushes available made from artificial
fibres, and they are satisfactory substitutes for those made
from natural fibres.

Cover
Moonlight Maiden
*Here the idea was to convey the feeling of a balmy summer
night by using warm, bright colours within a night time setting
where the use of black has been kept to a minimum.*

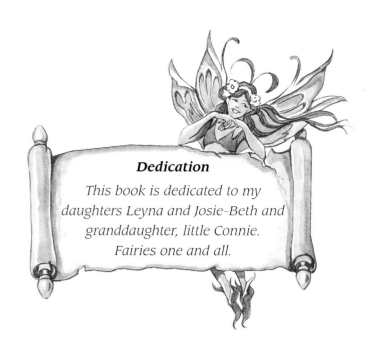

Dedication
*This book is dedicated to my
daughters Leyna and Josie-Beth and
granddaughter, little Connie.
Fairies one and all.*

Acknowledgements
*Thanks to Julie for the smiles of approval
when glancing over my shoulder during the
production of this book. A big thank you also to
Sophie Kersey (editor) and
Steve Crispe (photographer) for their undying
patience during the long hours of the step-by-
step photo shoot. Thanks again to Roz Dace for
her belief in all things 'other-worldly'.*

Page 1
Riding the Wind
*A limited palette of burnt sienna, yellow ochre, raw sienna and
a little black and white have been used throughout to create an
autumnal feel.*

Opposite
Painted Lady
*The title refers to the butterfly of the same name as well as the
content of the composition. The colours used here, yellows,
reds, pinks and violets, convey the feeling of a summer day.
The deliberately over-large eyes give the fairy the appearance of
youthful innocence.*

Contents

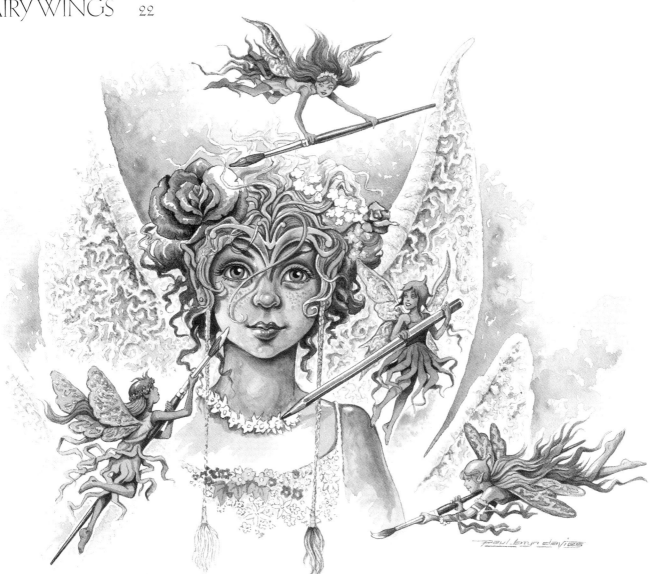

Introduction

When, as a young boy, I would disappear into my thoughts or daydream, my mother would comment: 'He's away with the fairies again!' Well, looking back that was probably true. Fairies have been a dominant theme within folklore and mythology for many years. There is something alluring about the idea of these tiny, ethereal beings flitting from plant to plant, hiding in tree trunks or under fallen leaves. There is a tendency to assume these creatures are exclusive to the country garden, woods or hedgerows. I prefer the idea that fairies can be found in the most unlikely places such as waste ground, alleyways or even window boxes in a sprawling metropolis. These may not be the most romantic of environments but they can make an interesting backdrop for your fairy composition.

In the Victorian era, some of the most influential artists and illustrators explored this subject matter to great effect. If you need inspiration, refer to the work of artists such as Arthur Rackham, Edmund Dulac and Richard Dadd.

In this book I have tried to keep the costume ideas as a mix between contemporary and the traditional, and with the use of make-up and even one or two tattoos, to inject some 'attitude' into some of the characters.

Drawing and painting fairies will give your imagination the opportunity to run riot, but it is important to remember there is no quick fix when it comes to creating a fantasy painting, and the investment of time, particularly in relation to your composition, will be very rewarding. Drawing figures can be difficult for some beginners and I hope some of the tips in the drawing section will help you with this. I have also included a page of expressions within this section, and as your confidence grows, these can help with defining the character of your fairy – will she be sweet and vulnerable, mature, juvenile, sensuous or just plain bad?

Some of the cartoon-style fairies you find dotted throughout the book can be fun to draw if you have young children or relatives. I hope you have fun painting fairies. Delve into your deepest imagination and, like me, drift 'away with the fairies'.

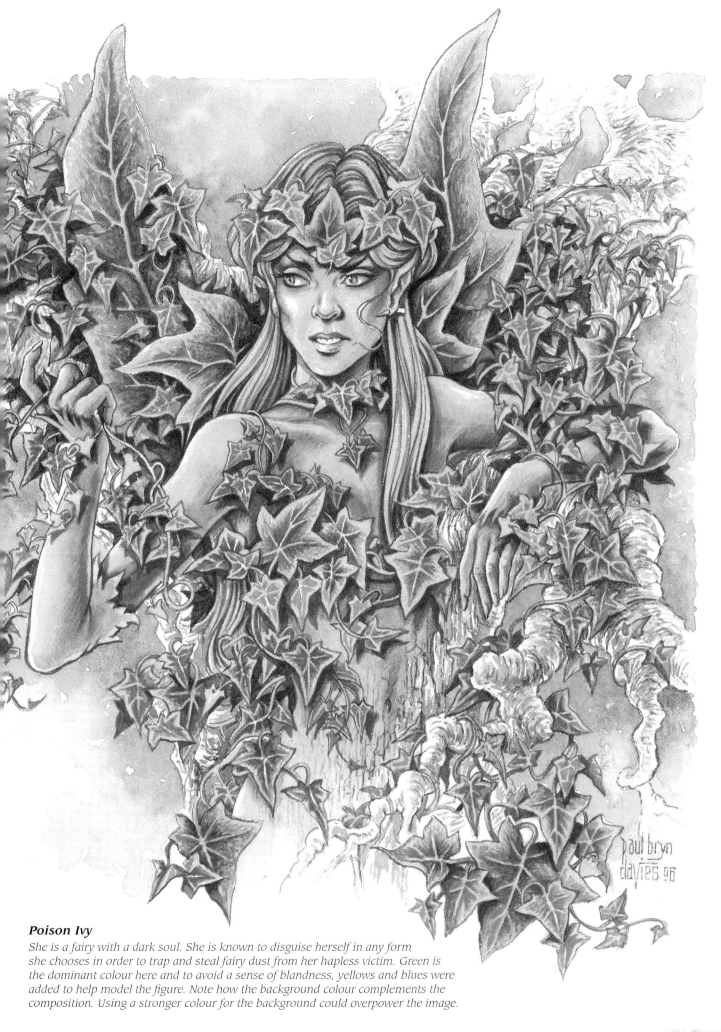

Poison Ivy

She is a fairy with a dark soul. She is known to disguise herself in any form she chooses in order to trap and steal fairy dust from her hapless victim. Green is the dominant colour here and to avoid a sense of blandness, yellows and blues were added to help model the figure. Note how the background colour complements the composition. Using a stronger colour for the background could overpower the image.

Materials

The quality of materials you use depends largely on how much you are prepared to pay. The range of products available can be daunting, especially for the beginner. Hopefully I can offer you some simple guidance to choosing the right materials to begin your journey.

PAINTS

Watercolours are available mainly in two formats: pans and tubes; and in two levels of quality: students' quality and artists' or professional quality. I would recommend tube paints which can be purchased as a beginner's set, and would suggest starting with around ten to twelve colours including the primaries. If your budget can stretch to artists' quality colours, all the better, as these offer richer pigments. I tend to use a combination of both students' and artists' quality colours and many of the compositions in this book were painted using only students' quality colours. You should also add some white gouache to your collection. Watercolour has a translucent quality whereas gouache offers a great deal of opacity, which makes it ideal for highlighting.

A selection of artists' and students' quality watercolour paints in tube form.

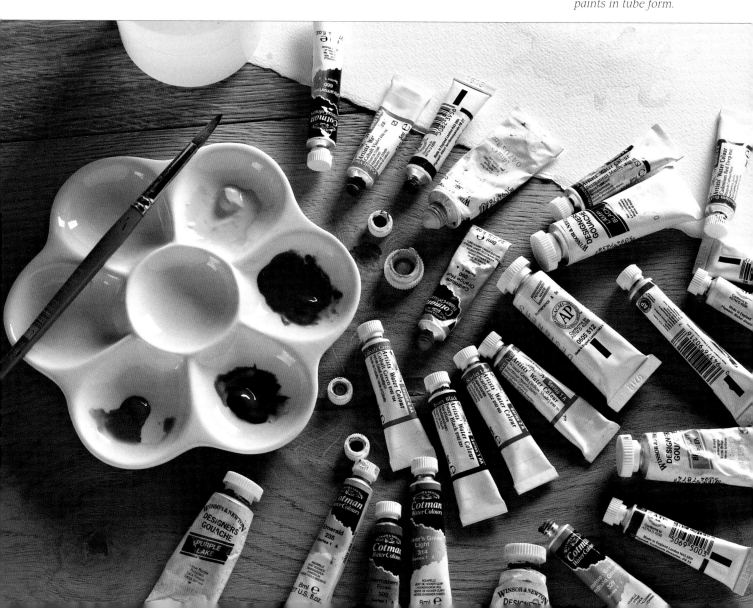

BRUSHES

This area can also be something of a minefield with such a wide range of choices. Brushes are available as pure sable, a sable/synthetic mix and plain synthetic (the cheapest). Pure sable brushes are the best quality choice, but are expensive. Some of these are handmade and individually tested by the manufacturer, so you can imagine the cost! This quality of brush will give you the perfect combination of carrying a useful amount of paint and ease of control; and they will also keep a fine point. As a compromise I would recommend using sable mix brushes, as these will be more than adequate. Use numbers 0, 1, 2 and 3 for detailing, and numbers 5, 6, and 7 for the broader colour washes used for the skies and the basic backgrounds. Synthetic brushes are adequate for larger wash areas.

From top to bottom: no. 3 hog hair flat, no. 2 hog hair flat, no. 4 hog hair flat, no. 7 synthetic round, no. 6 synthetic round, no. 1 sable, no. 2 sable and no. 0 sable.

PAPER

This is not an area in which to cut corners. Watercolour paper is available in various finishes from smooth to rough and various weights. Cockling or buckling of the paper can be avoided by using a heavier grade paper when applying larger areas of colour wash. The heaviest paper is 640gsm (300lb) and is more like card than paper. The ideal weight I would recommend when getting started would be 140lb (300gsm). The finishes or surface textures of watercolour paper are: HP which stands for hot pressed, and is very smooth; NOT or cold pressed (semi-rough); and rough, which is heavily textured. The majority of the paintings in this book were produced using 300gsm (140lb) NOT finish paper, with the exception of *The Wandmaker* (page 13), *The Gift* (page 17), the fairy face and hair pictures on pages 18–19, the fairy wings on page 22 and the index page painting, all of which were painted on HP (smooth) finish paper.

You will also need ordinary printer paper for preliminary sketches, and tracing paper for transferring drawings on to watercolour paper.

BOARD

The top of your working surface needs to be smooth and stable, so for the projects covered in this book I feel a drawing board would be the most suitable. An easel is more often used for looser, sketchy subjects and would probably lack the stability you need for the detail work, but is a good alternative to a drawing board. Purpose-made drawing boards are ideal but can be expensive as they often come complete with a parallel motion mechanism for squaring up your work. A practical, cheaper option is a piece of MDF (medium density fibreboard) measuring around 650mm x 480mm (25½ x 19in). You could also use a piece of melamine (plastic) faced chipboard. This is the surface I prefer to work on. Both of these items can be purchased from your local DIY store – they may even cut them to size for you.

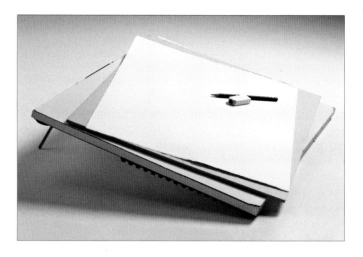

A professional drawing board and a piece of MDF, both suitable to use as boards on which to support your watercolour painting.

OTHER ITEMS

Pencils and sharpener You will need a hard point (H); medium-hard (HB); and a softer grade (B). Keep a good point on your pencils using the sharpener.

Eraser Use a soft grade or putty eraser (a harder one can damage the surface of your paper) in the unlikely event you make a mistake!

Kitchen paper This is for wiping off excess paint from your brushes, mopping up spillages and lifting out or softening colour.

Masking tape Used to secure your paper to the drawing surface or board.

Tracing paper or pad Available in sheet or pad formats, this is used for transferring your rough layouts to the watercolour paper surface, and for tracing from photographs. You can buy 60 or 90gsm weights.

Burnisher A purpose-made tool for transferring your tracing to a new sheet of paper. You can use a ballpoint pen cap, brush handle or similar item instead.

Layout pad/sketch pad or printer paper For creating your first drafts and planning your compositions.

Hairdryer A hairdryer can be used to speed up the drying process, and helps prevent the paper cockling.

Light box This is a luxury, but if you can afford one, you can save time when tracing. The light box can save time as your rough drawing can be traced in reverse, thus eliminating the need to go over the tracing twice.

Palette Try to use the traditional china palettes as these are stable and make colour mixing easier. A cheaper alternative would be a plastic palette or even an old tea plate or saucer.

Water pot The ideal container is a plastic, spill-proof pot. This is inexpensive and can help to avoid accidents. If this is not available, the good old jam jar is a great alternative.

Toothbrush An old toothbrush can be used for creating spattering effects such as fairy dust (see page 11).

Masking fluid Used for creating special effects and protecting previously painted detail (see page 11).

Fine ballpoint pen This is a preference of mine when preparing compositions but is not essential. If you prefer, simply detail your roughs with pencil.

Ruler This can be used for brush ruling (see page 37).

A water pot, masking fluid, masking tape, palettes, toothbrush, kitchen paper, light box, ruler, sharpener, printer paper, pencils, fine ballpoint pen, burnishers and eraser.

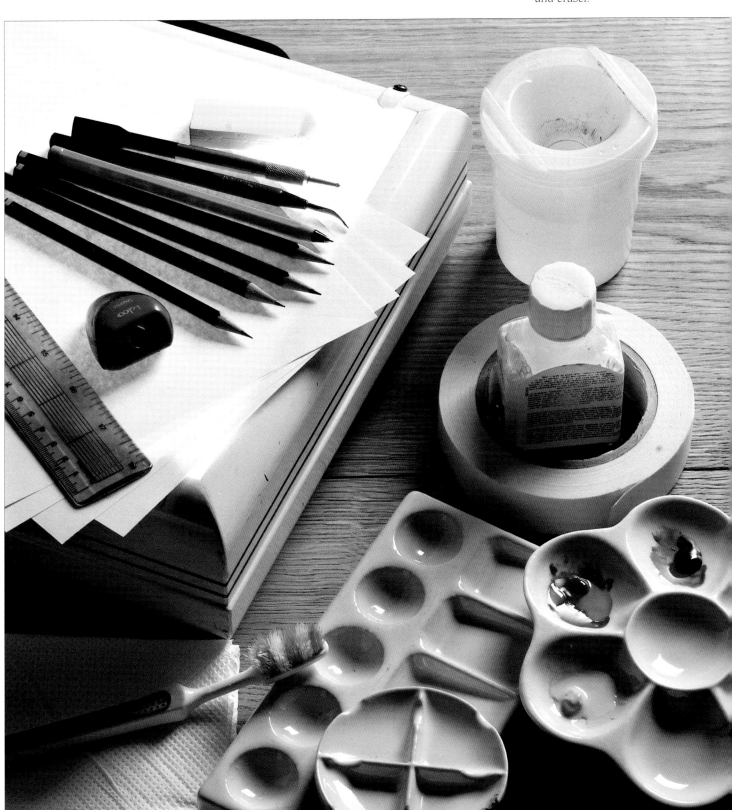

Techniques

The following two pages show some basic techniques to help you get started. The ideas shown on this page will be useful for creating a backdrop to your fairy image. Those opposite could be used for adding special effects such as fairy dust or textured effects to clothing.

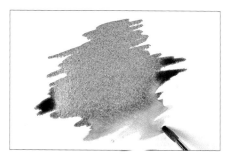

TIP
Lean your painting hand on scrap paper to keep the painting clean.

WET IN WET

This technique could be used to create a graduated wash for the background of a painting.

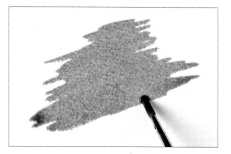

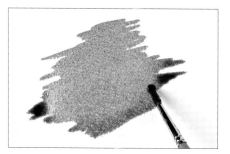

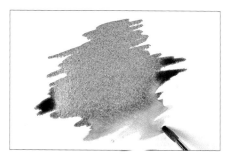

1 Make a thin wash of Winsor violet and paint it on using a no. 6 round brush.

2 While the first wash is wet, paint on a thin wash of permanent rose so that it blends in.

3 Add clear water to soften the edge of the pink area.

WET ON DRY

This technique is used for adding detail on to a wash background such as mountains or trees, or the fairies themselves.

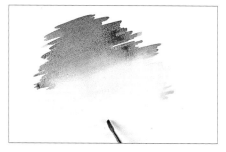

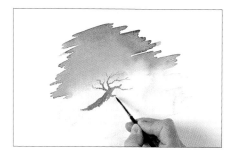

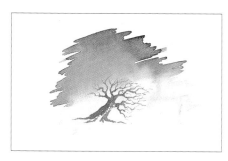

1 Create a graduated background wash as above using permanent mauve and new gamboge. Allow the wash to dry.

2 Use a no. 2 sable brush and Winsor violet to paint your image. Leave some areas of background showing to suggest highlights. Use a drier brush for the finer details.

The finished painting.

SPATTERING

This effect can be achieved by using an old toothbrush or a hog hair brush
and can create a simple fairy dust effect.

1 Dip the toothbrush in fairly thick ultramarine paint. Dab the excess on to scrap paper. Pull back the bristles to spatter paint over the paper.

2 Rinse the toothbrush, dip it in thick permanent rose paint and spatter the area again.

3 Rinse the toothbrush and spatter with a thick mix of new gamboge and Chinese white.

STIPPLING

Mix your paint to a fairly thick consistency and use a stiff hog hair brush to
create soft background images such as those shown on pages 26–27.

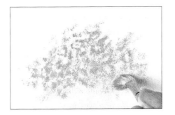

1 Pick up cobalt green on your brush. Remove any excess on scrap paper. Hold the brush vertically and stipple on texture.

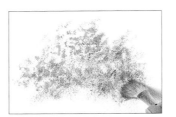

2 Mix ultramarine with cobalt green to darken areas of shadow, and continue stippling. Use pure ultramarine for the darkest parts.

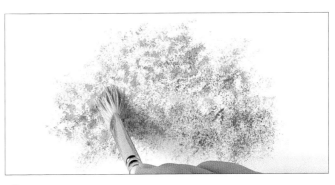

3 Wash the brush thoroughly. Mix new gamboge and Chinese white and stipple on as shown.

MASKING

Masking fluid can be used for a number of purposes in addition to those shown
below, such as masking your fairy image when a background wash is required
or when spattering.

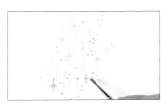

1 Shake the masking fluid first and using an old no. I brush, paint on stars and dots. Wash the brush immediately in soap and warm water.

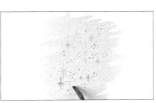

2 Paint a wash of new gamboge over the masking fluid.

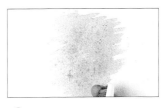

3 While the paint is wet, spatter on permanent rose. Allow to dry.

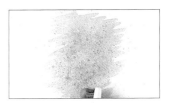

4 Spatter again with a stronger mix of permanent rose.

5 Use a very soft eraser and gentle, circular movements to remove the masking fluid.

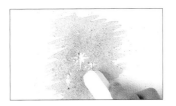

The finished effect.

Colour

When painting fantasy figures, the colours you use are largely a matter of taste. You may see your fairy with very subtle, almost monochromatic colours or you may prefer to marry a lighter, more pastel hue to something deeper and more robust. As a general rule, try to choose colours that complement each other. Here are a few ideas to help you get started.

Top to bottom: cobalt violet, permanent mauve and dioxazine violet. Similar colours were used on Moonlight Maiden *(cover) and* Plant Life *(page 46).*

Top to bottom: new gamboge, Winsor green and intense blue. Similar colours are used on Poison Ivy *(pages 4–5).*

Top to bottom: new gamboge, cadmium orange, cadmium red deep.

Top to bottom: cobalt violet, cerulean blue and ultramarine.

Top to bottom: cadmium yellow, burnt sienna and Indian red. Similar colours were used in Autumn Wings *(page 38).*

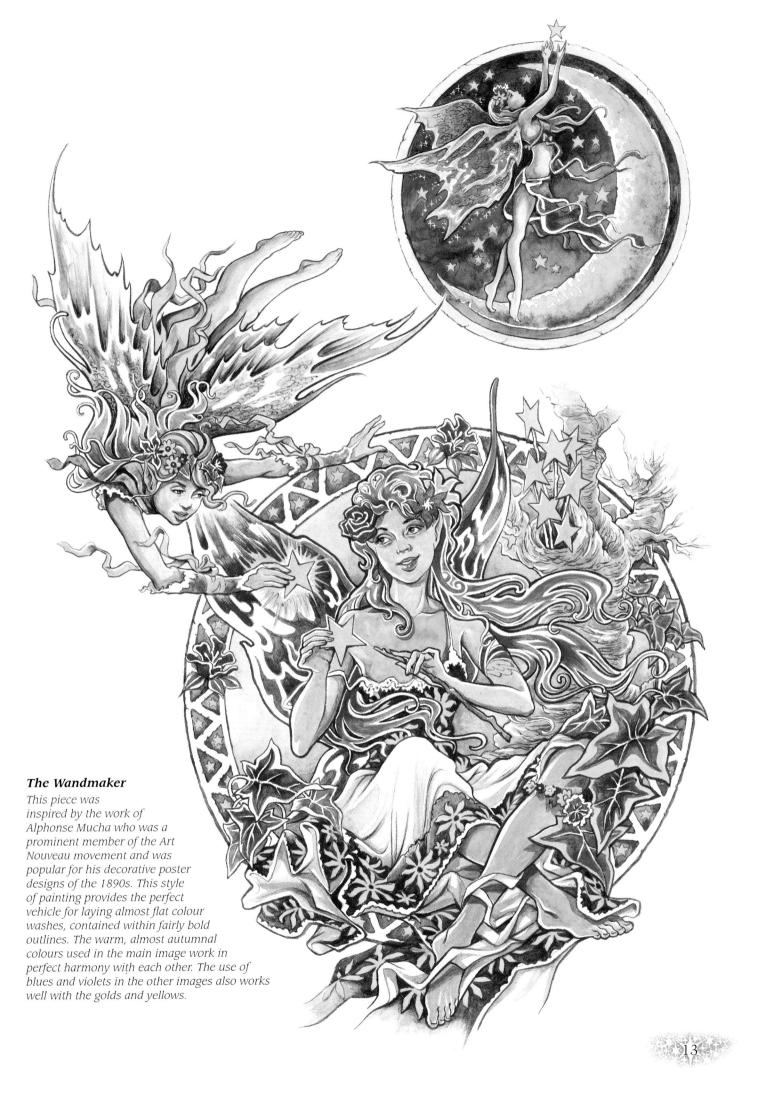

The Wandmaker

This piece was
inspired by the work of
Alphonse Mucha who was a
prominent member of the Art
Nouveau movement and was
popular for his decorative poster
designs of the 1890s. This style
of painting provides the perfect
vehicle for laying almost flat colour
washes, contained within fairly bold
outlines. The warm, almost autumnal
colours used in the main image work in
perfect harmony with each other. The use of
blues and violets in the other images also works
well with the golds and yellows.

13

NATURAL SKIN TONES

Below are a group of simple colour swatches used for realistic skin tones. You may find these helpful when deciding the style or ethnicity of your fairy.

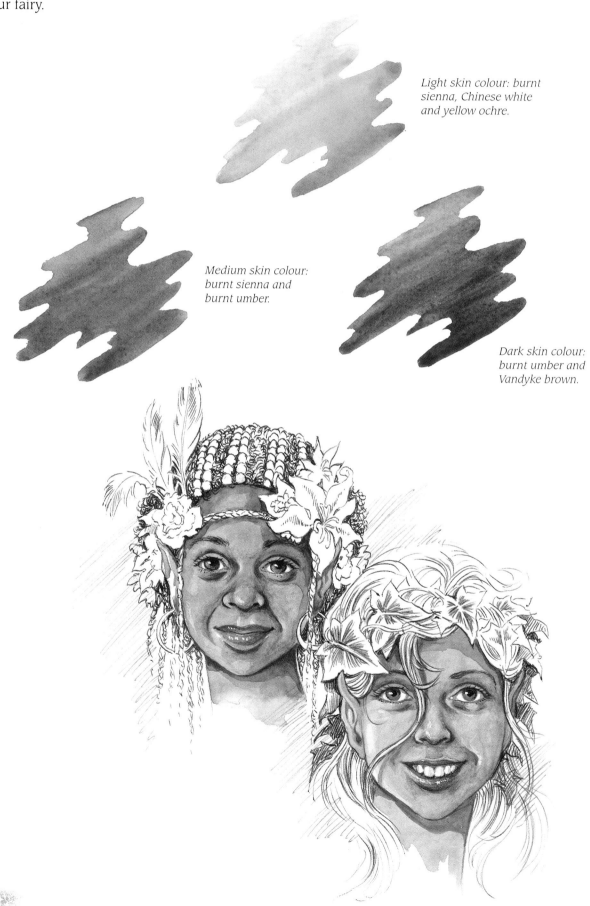

Light skin colour: burnt sienna, Chinese white and yellow ochre.

Medium skin colour: burnt sienna and burnt umber.

Dark skin colour: burnt umber and Vandyke brown.

FANTASY SKIN TONES

As previously mentioned there are no rules to painting your fairies and that goes for skin colour too. Here are a few wacky ideas to get those creative juices flowing!

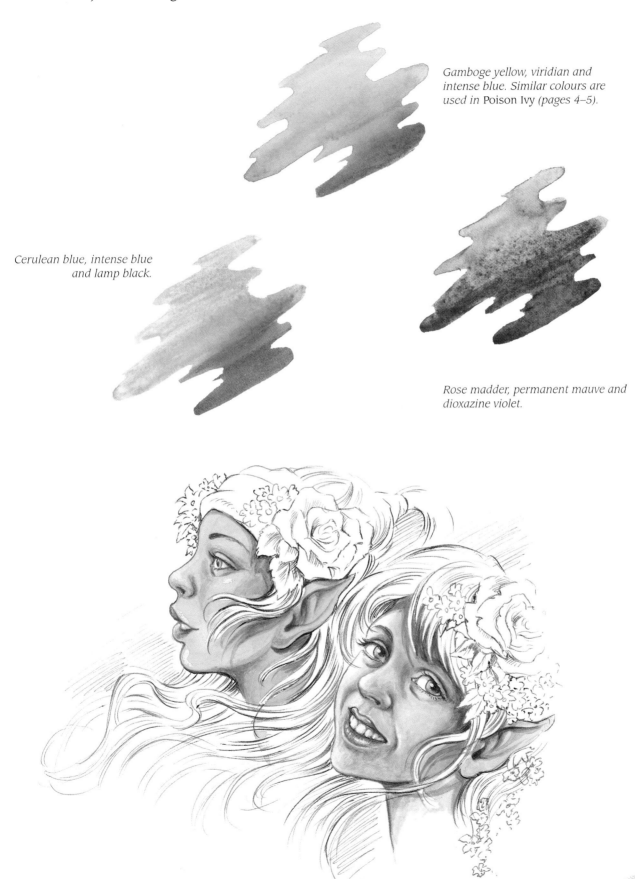

Gamboge yellow, viridian and intense blue. Similar colours are used in Poison Ivy *(pages 4–5).*

Cerulean blue, intense blue and lamp black.

Rose madder, permanent mauve and dioxazine violet.

Drawing fairies

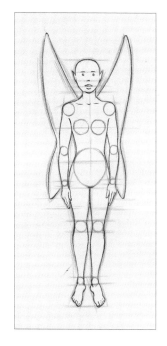

Before starting your painting (if you are a beginner) it is very important to practise your drawing skills. Sketching a friend or relative can help with the proportions as can referring to photographs: magazines or mail order catalogues can help with this. If this proves difficult, why not purchase an artist's mannequin? This is a model that can be manipulated into many positions and shows the proportions of the limbs and joints, as in the diagram on the right.

The proportions of a child fairy like the one shown below will differ from those of an adult. The head will be somewhat larger in proportion to the body and the torso, arms and legs will be plumper.

1 Using circles and oval shapes to represent the various limbs and joints, construct your figure with an HB or B grade pencil. Use only the minimum of pressure.

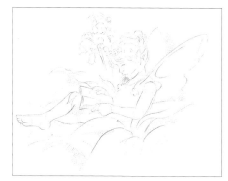

2 Once you are happy with the composition, work up the details to form the basic human shape using the same grade of pencil.

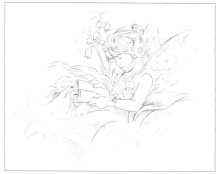

3 Work the sketch up into a more detailed drawing. I have used a fine ballpoint pen, but you may prefer to continue the detailing using a pencil.

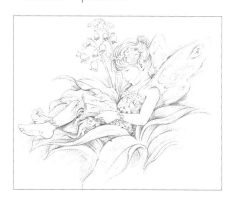

4 This is the final draft which will be the foundation for the watercolour. A detailed trace is then made and the drawing is transferred to the watercolour paper using the methods shown on pages 30 and 40.

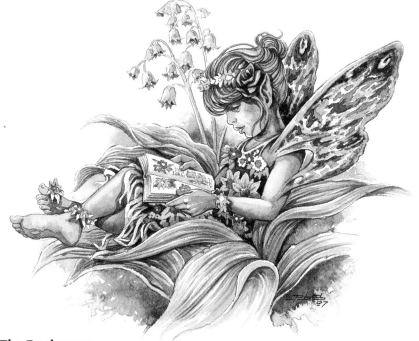

The Bookworm
The piece is finished with a limited palette of yellow ochre, burnt sienna, gamboge hue, burnt umber, a little black and dioxazine violet.

USING PHOTOGRAPHIC REFERENCE

This is probably the easiest and quickest way to get your basic figure constructed. Once you have the outline of the figure, you can begin to customise and model the sketch into the form you wish your fairy to take.

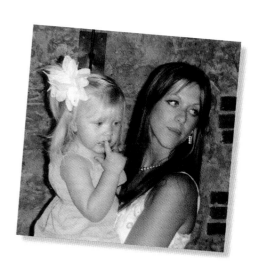

The reference photograph used for this piece, which shows my daughter, Leyna, and granddaughter, Connie. Connie did not want her photograph taken and had to be distracted by the television over her Mum's shoulder, which is where I added the smaller fairy.

1 Using a sheet of tracing paper, trace your photograph lightly using an HB pencil. Flip over the paper and draw over the lines you have drawn on the other side.

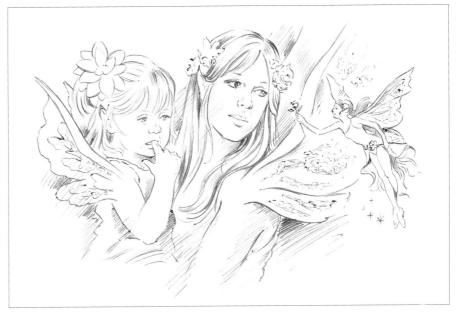

2 Transfer the trace to some layout or printout paper. Now you can be really creative by adding the wings, clothing and other embellishments. I have used a fine ballpoint pen to do this, but you may choose to use a pencil or fine felt tip pen instead. You are now ready to retrace your drawing, as in step 1, ready to transfer it to your watercolour paper.

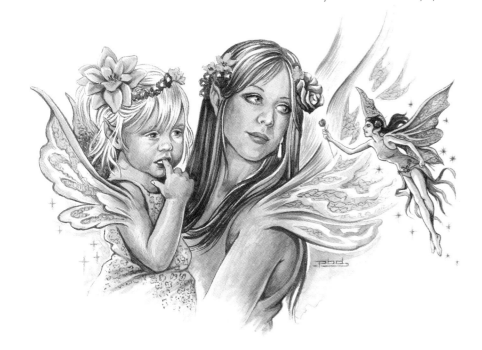

The Gift

The finished piece is painted on HP (smooth) finish 140gsm paper using a combination of students' and artists' quality colours. The small fairy was painted in lilacs which helps separate her from the main image and adds narrative to the piece.

Fairy faces

The faces and expressions you choose for your fairies will depend on the composition and the age group you have selected. This page shows some of the basics to help get you started when constructing the face, and how to vary the proportions to give your fairy a more ethereal look.

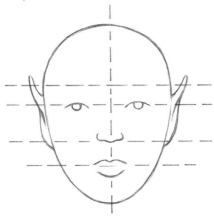

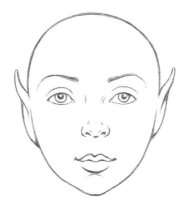

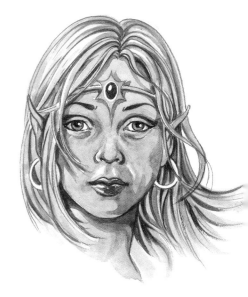

1 Sketch an oval shape on to your layout paper, making the top slightly wider than the bottom. Now, using a pencil, plot the positions of the eyes, nose and mouth using the minimum of pressure.

2 Detail the eyes, mouth and ears. This face is representative of a young adult. A more juvenile look can be achieved by drawing a rounder face, larger eyes and a smaller, shorter nose. At this stage you can decide on the hairstyle (see page 19) and add this accordingly.

3 The finished painting. Here you can add embellishments such as flowers, jewellery and eye make-up if you wish.

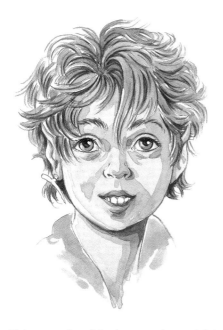

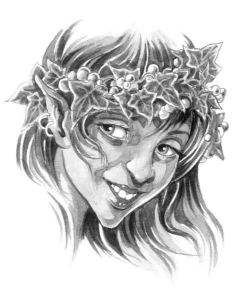

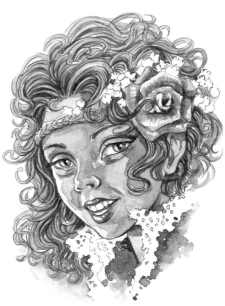

This young boy fairy has over-large violet eyes that add a mystical quality. The tousled hair, small mouth and chin also add a feeling of innocence.

This young fairy has larger eyes and a pointed chin which give her a slightly elfin look – and of course, pointed ears.

This fairy also has over-large eyes. The shape is narrower, suggesting this fairy is impish and mischievous in character.

EXPRESSIONS

This subject can prove quite taxing for the inexperienced artist, but often fairly simple distortions of the facial features can help to create recognisable expressions.

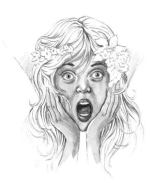

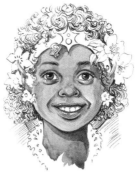

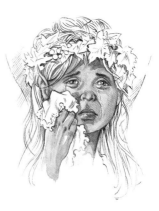

Sad

Narrow the eyes and draw them down slightly toward the outer edges. Narrow the mouth and turn the edges down slightly. For added effect, add some red around the eyes and on the nose.

Astonished

Widen the eyes to create an almond shape and make the iris appear smaller. Open the mouth and lift the eyebrows.

Happy

Lift the eyebrows, widen the eyes and widen the mouth to show some of the teeth.

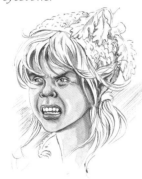

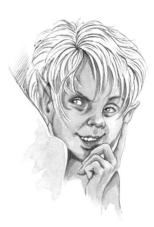

Mischievous

This is probably the trickiest expression to create. Lift one eyebrow, lower the other and narrow one of the eyes. Twist the mouth slightly into a sly smile.

Angry

Narrow the eyes and draw the eyebrows down in the centre. Flare the nostrils and grit the teeth.

HAIR

Hair can be a great way to define the type, age and even ethnicity of your fairy. Take references from hair or fashion magazines to help with the basics, then add some of your own ideas – the quirkier the better.

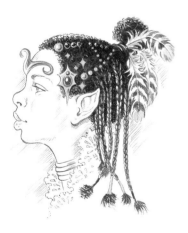

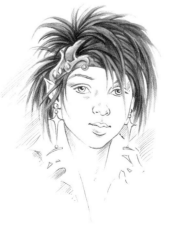

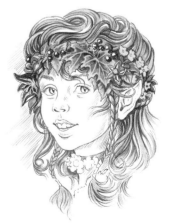

This fairy, of African descent, uses traditional braiding to style her hair like a Massai warrior. The beads and feathers along with other adornments underline the tribal feel.

This hairstyle could suit an adolescent fairy from an urban environment. The use of vivid colour and the dishevelled style give her a fun and streetwise look. See City Flyer *on page 47.*

This country fairy has a more traditional hairstyle and the addition of flowers, leaves and berries underlines the natural look.

Fairy limbs

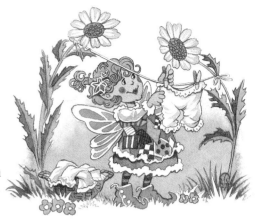

Drawing the limbs, especially the hands and feet, can present problems for the inexperienced artist, but there are a few simple things you can do to make this task easier. Firstly, study photographic reference to familiarise yourself with the proportions. The various shapes and the curvature that an arm or leg may take on when relaxed or under pressure can often be seen in sports books, fitness catalogues or similar publications. Ballet photographs can be particularly useful. An artist's mannequin can also help in this area.

ARMS AND HANDS

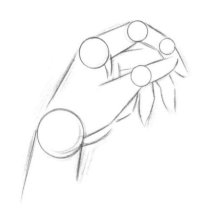

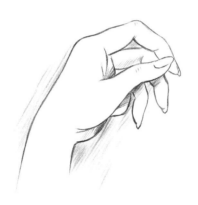

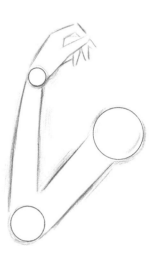

1 Try to think of the construction of the hand as a series of rods and balls, the circles representing the positions of the various joints. This sketch uses this method for the basic construction.

2 When the positions of the various joints are plotted, you are ready to model the hand into a more realistic shape, as shown.

3 This sketch shows the position of the various limb joints which can then be modelled into a more realistic shape, as with the hand.

This drawing shows how the modelled hand and arm could appear within a composition.

LEGS AND FEET

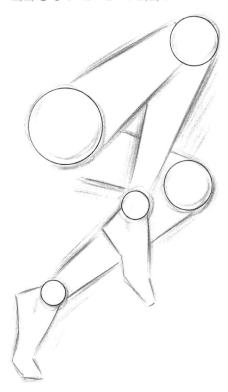

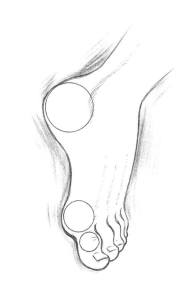

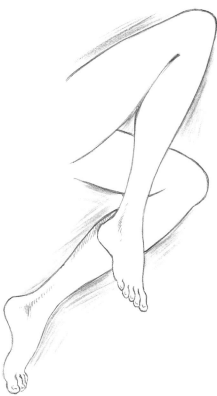

2 Begin to model the foot into a more realistic shape.

1 Lightly sketch a series of rods and balls, checking with your reference that the proportions are correct in relation to one another.

3 The modelled legs and feet, ready to paint.

This drawing shows the importance of taking the time to construct the limbs correctly and how they are an integral part of the final composition.

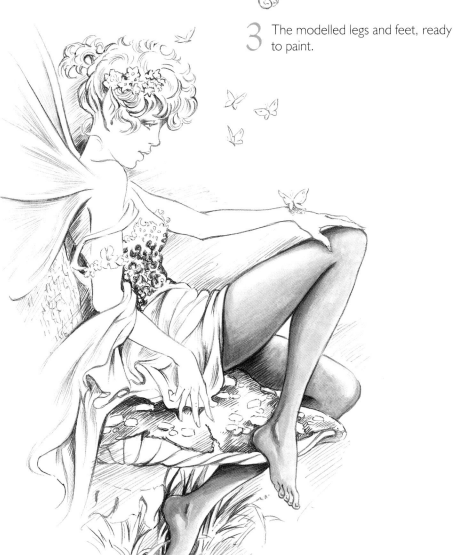

Fairy wings

ere is a group of fairy wings with an eclectic mix of styles. Arguably the most important characteristic of your fairy, the wings can be as simple or complex as you like. The wings of butterflies, moths and dragonflies can be useful reference points to help get your wing designs started. Even the form of a bat's wing can be useful if you want to construct a fairy with perhaps a more Gothic look.

Dragonflies and lacewings were the inspiration behind these relaxed fairy wings. This design allows you to create different patterns within the contours of the wing. I used Winsor green and gamboge hue and added intense blue to the green for the deeper areas of colour.

This fairy shows how the wings may appear in flight. Note how the tips of these double wings are turned upwards, giving the impression of floating on air. The use of feathers on the wing tips has been kept to a minimum, so that the fairy will not be mistaken for an angel. I used cerulean blue, cadmium red and cobalt violet.

The skeletal form of this wing was inspired by a bat's wing. The colours are dioxazine violet, permanent rose and burnt sienna.

These wings are loosely based on those of the swallowtail butterfly. Various embellishments have been added to give a fantasy feel. This view shows how the underside of the wing may differ from the upper side. I used gamboge hue, raw sienna, dioxazine violet and scarlet lake.

Black Rose

As her name suggests, this is a fairy from the darker side. Her habitat is urban wasteland where she has stopped to repair a tear in her wing. The skeletal structure of the wing is loosely based on a bat's wing, giving her a Gothic appearance. The largely black clothing strengthens the Gothic feel while the lace trimming and flowers remind us of her underlying femininity. When painting larger areas of black, try feeding other colours such as blue, red, or, as in this example, violet, wet in wet into the mix to add interest.

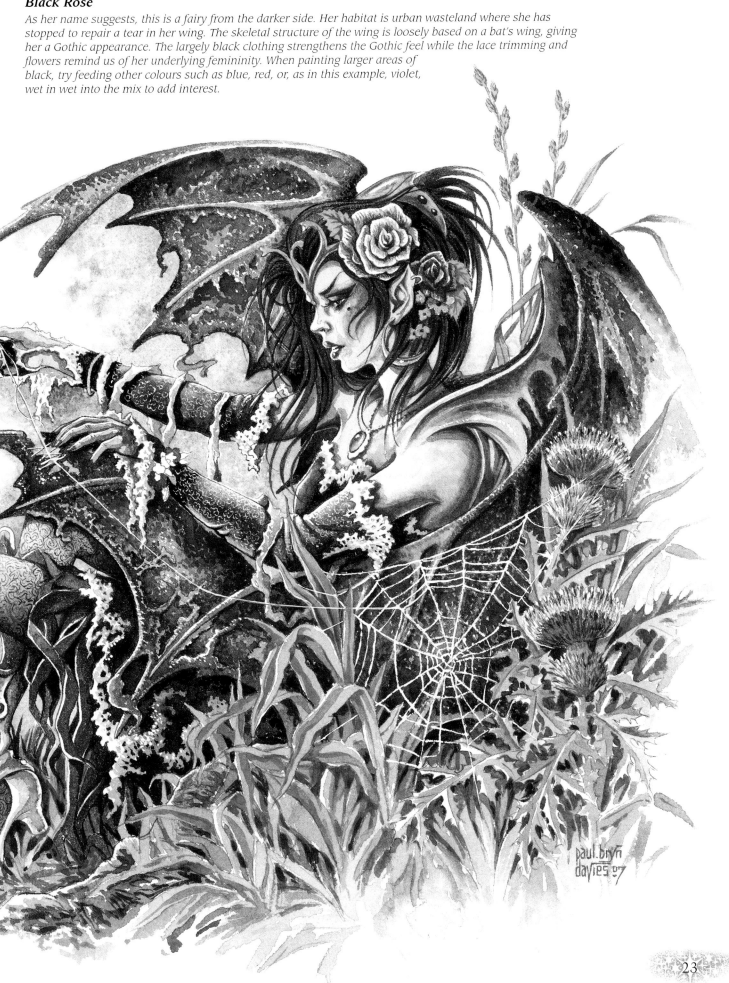

23

Fairy clothes

These pages are designed to give you some ideas for clothing and are roughly split into two areas: country and city or urban. There are no rules to how fairy clothing may look, but I feel using simple looking fabrics and colours along with natural elements such as leaves, flowers or vines would be suitable for a fairy in a rural setting, whereas the use of leather, satin and more man-made fabrics would suit the urban fairy – see *City Flyer* on page 47. Use pastel colours (yellows, greens and pinks) for a country look and more positive colours (mauves, reds or black) for a city feel. A fine ballpoint pen was used for the linework on all fairies.

This urban fairy uses mauve, dioxazine violet and gamboge for the lace work. Burnt sienna was used for the trousers and bodice, suggesting a leather fabric or something similar.

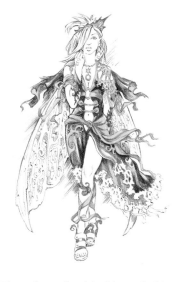

The colours for this fairy's clothing are limited to gamboge, burnt sienna and cadmium red deep.

A simple dress style with a country feel was needed here. I used Winsor green with gamboge yellow, with intense blue added for the shadowing and deeper recesses. Cadmium red and intense blue were used for the flowers.

Again, simplicity of dress is the guide here: leaves simply tied with twine make up the main costume and berries are used for adornment. The colours are similar to those used for the fairy on the left.

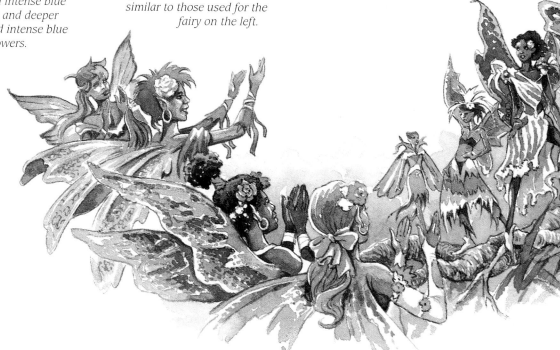

Hedgerow Divas

It can be fun to add an element of humour into your paintings. Here a fallen branch forms the catwalk for these fashionable fairies to strut their stuff and show off the latest outfits. There is an obvious temptation to add greens, yellows and browns to a composition within a country setting but I have avoided this here. The skin tones were created from burnt sienna, yellow ochre and Chinese white, and the clothing and foliage from mauve, dioxazine violet and yellow ochre in various mixes. Payne's gray was used with mauve added for the fallen branch. Yellow ochre is the dominant grass colour.

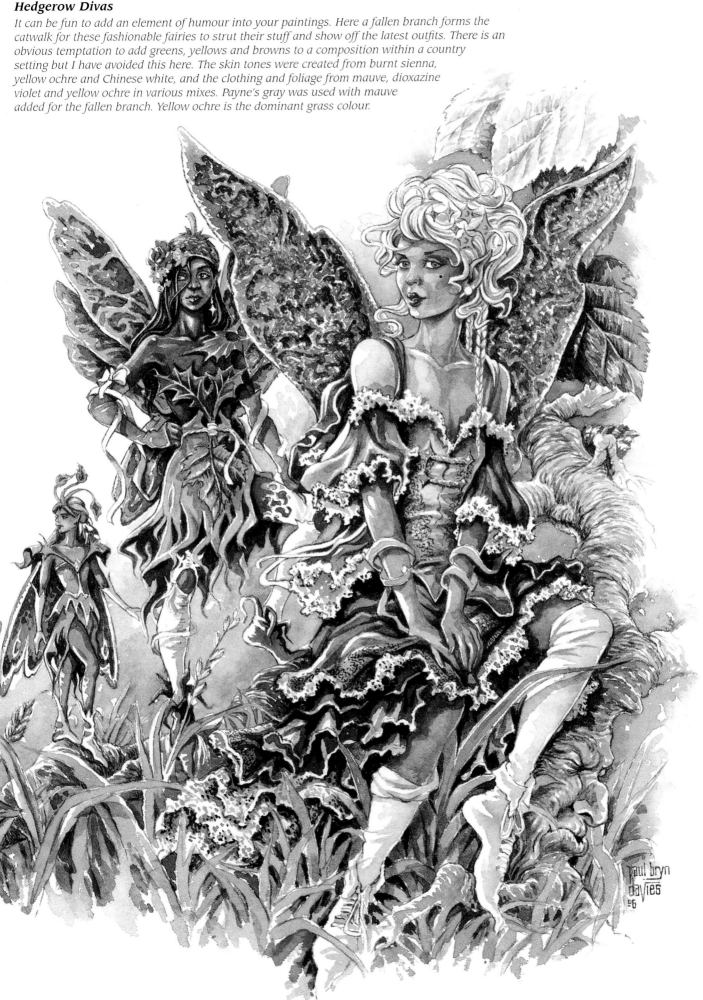

Backgrounds

Creating a background to your painting helps to set the mood, period, and time of day or night in which to place your fairy. Try to keep backgrounds as simple as possible. This prevents the painting from looking cluttered and keeps the focus of attention on your fairy – the main purpose of the composition. The style needs to be soft and fairly loose and the depth of colour watery. Remember to keep the colour more intense towards the top of the sky and in the immediate foreground, paling in colour and intensity toward the horizon.

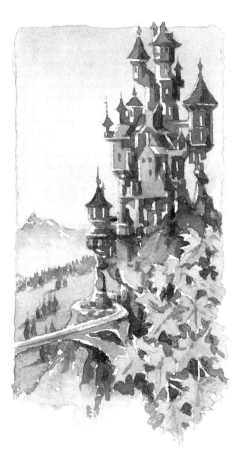

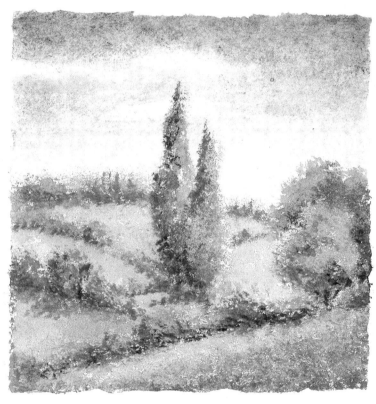

This small landscape makes use of the stippling effect described on page 11 and gives an impressionistic effect. The sky colours were stippled with a base of Prussian blue and white with mauve overlaid at the top. The base colour for the land mass is a mix of gamboge hue and Chinese white. Cobalt green with gamboge hue has been added to this intense green for the foliage. Prussian blue was added to the greens for the darker areas. Some of the stippling was softened by adding a wash of clean water with no colour added.

Greens were planned as the overall colour scheme here. The sky colours are gamboge hue mixed with Chinese white to a watery consistency and applied with a no. 2 sable brush. To keep the colour deeper toward the top, cobalt green was added wet in wet to the mix. The castle was painted with a mix of Payne's gray and intense green. Intense blue was added to this mix for the shadowed areas. The remainder of greens in the painting are mixed from gamboge hue and intense green.

The paper was allowed to show through to create highlights. This effect can also be achieved by using white gouache for its opaque quality.

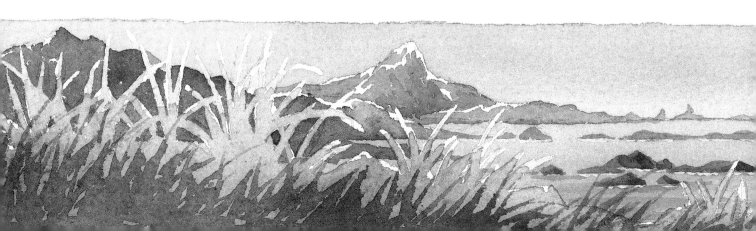

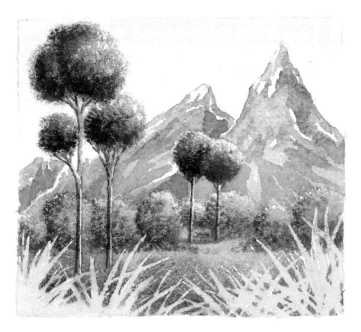

This landscape features both traditional watercolour techniques and stippling. The grass in the foreground was created using masking fluid followed by a colour wash of gamboge hue. A mix of violet and ultramarine blue was used for the mountains with a slightly stronger mix for the darker areas. The same colours were used for the trees as a stipple effect. Gamboge hue stippled with mauve, violet and ultramarine was used for the remainder of the foliage.

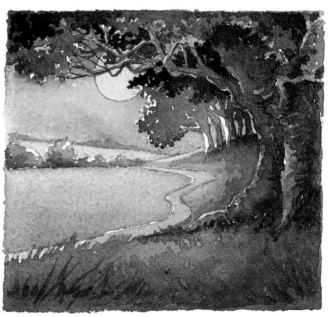

A night time or moonlit scene can create an atmospheric backdrop for your fairy painting. Masking fluid was used to cover the moon and a wash of Prussian blue and mauve was added wet in wet. The green areas were applied using a watery mix of Hooker's green light with Prussian blue added to the wash. Colours can be varied for this style of setting as shown in Moonlight Maiden on the front cover, which makes greater use of violets and mauves.

This panoramic seascape underlines the need for simplicity when painting backgrounds. Masking fluid was applied to the grassed area in the foreground and a watery mix of Paynes' gray, dioxazine violet and Chinese white was added for the sky. Yellow ochre was blended into this mix wet in wet using a no. 6 synthetic mix brush. The sea features the same colour scheme with extra dioxazine violet added to the foreground to add depth. Burnt umber has been added wet in wet to the castle and the rocky pathway in the foreground. The distant mountains are painted with a deeper mix of the colours used in the sky and the rocky outcrops in the sea are this same mix with extra violet added for the darker areas, which were painted wet on dry. The masking fluid was removed and a wash of yellow ochre with dioxazine violet was applied wet in wet. This was dried and the grass in the immediate foreground was painted wet on dry with a fairly strong mix of dioxazine violet and burnt umber using a no. 2 sable brush. Finally, the white gouache highlights have been added using the same brush.

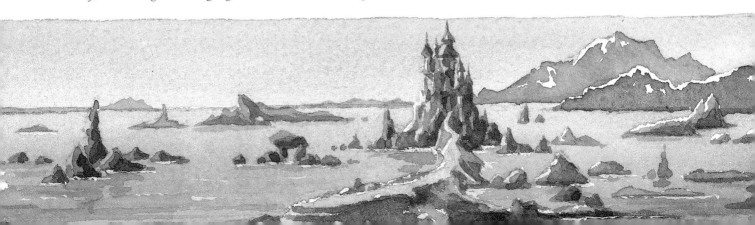

Foregrounds

These pages are designed to illustrate some details of the haunts or situations your fairy may inhabit. When combined with looser, softer background washes, these foreground details can create a greater feeling of depth if you are placing your fairy within a scene. They also give the fairy a sense of scale within the composition. Your garden, local woods or park can provide you with inspiration.

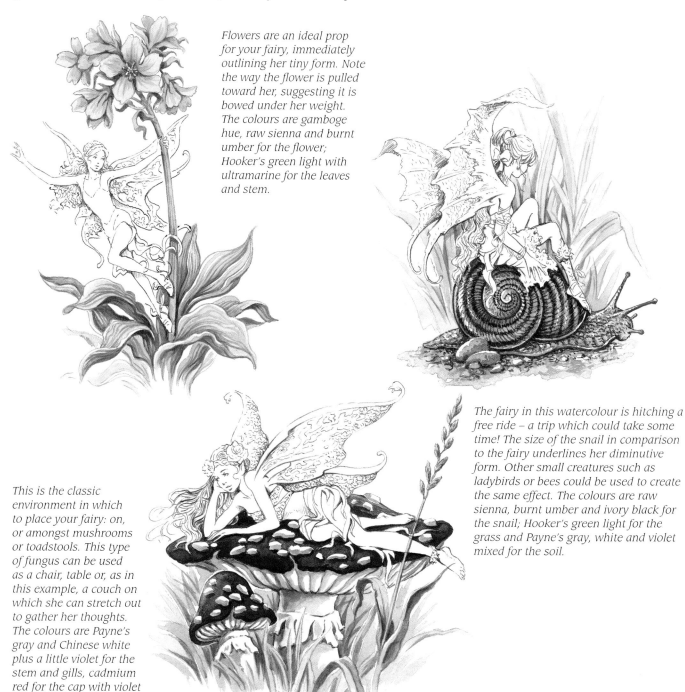

Flowers are an ideal prop for your fairy, immediately outlining her tiny form. Note the way the flower is pulled toward her, suggesting it is bowed under her weight. The colours are gamboge hue, raw sienna and burnt umber for the flower; Hooker's green light with ultramarine for the leaves and stem.

The fairy in this watercolour is hitching a free ride – a trip which could take some time! The size of the snail in comparison to the fairy underlines her diminutive form. Other small creatures such as ladybirds or bees could be used to create the same effect. The colours are raw sienna, burnt umber and ivory black for the snail; Hooker's green light for the grass and Payne's gray, white and violet mixed for the soil.

This is the classic environment in which to place your fairy: on, or amongst mushrooms or toadstools. This type of fungus can be used as a chair, table or, as in this example, a couch on which she can stretch out to gather her thoughts. The colours are Payne's gray and Chinese white plus a little violet for the stem and gills, cadmium red for the cap with violet added for the shadows.

This old tree trunk was spotted close to where I live and with the gaping hole in its side and the heavily entwined ivy it seemed the perfect habitat for a fairy. The colours are: Payne's gray, burnt umber, raw sienna and black for the tree trunk and Hooker's green light for the grass with dioxazine violet for the darker areas.

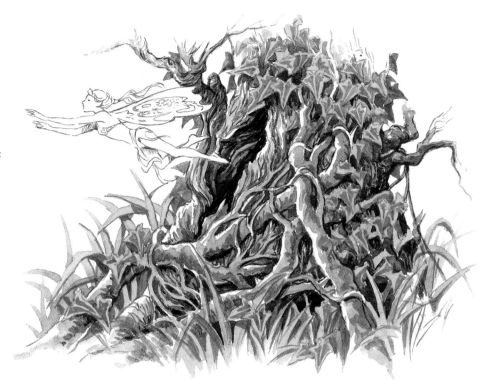

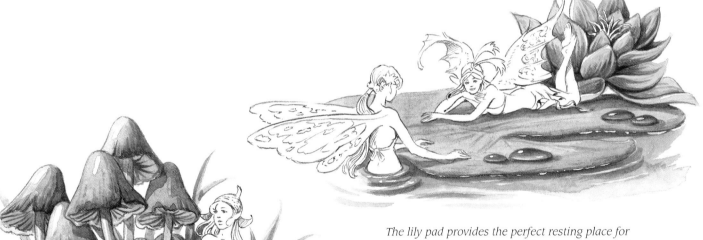

The lily pad provides the perfect resting place for the water fairy. The flower colours are gamboge hue and permanent rose. Dioxazine violet was added to this mix for the shadow areas. The lily pad is intense green with gamboge yellow. Intense blue has been added to the mix for the deeper shading. The water is intense blue and Hooker's green light with permanent white gouache used for highlighting.

This group of toadstools gives a good sense of scale to the fairy and the grass blade is bending under her tiny weight. The toadstool colours are burnt umber and Chinese white with more burnt umber and a little violet added for the shadows. The grass is Hooker's green light with violet added for the shadows.

Autumn Wings

It is always beneficial to plan your project thoroughly. Once you are happy with your composition, take the time to think about the colours you wish to use and what sort of feel you want for the painting. For instance, when I had finished the initial sketches for this piece, it came to mind that it could have an autumnal mood. This then dictated the palette and warm colours were chosen accordingly.

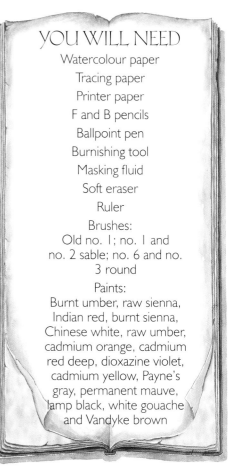

YOU WILL NEED

Watercolour paper
Tracing paper
Printer paper
F and B pencils
Ballpoint pen
Burnishing tool
Masking fluid
Soft eraser
Ruler
Brushes:
Old no. 1; no. 1 and no. 2 sable; no. 6 and no. 3 round
Paints:
Burnt umber, raw sienna, Indian red, burnt sienna, Chinese white, raw umber, cadmium orange, cadmium red deep, dioxazine violet, cadmium yellow, Payne's gray, permanent mauve, lamp black, white gouache and Vandyke brown

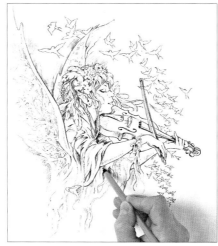

1 Sketch the image in pencil first.

2 Work up the final drawing on ordinary printer paper, using a fine ballpoint pen. You can include hatching to suggest tone.

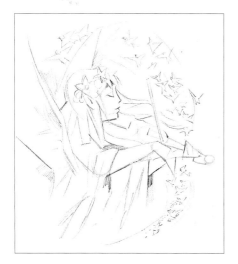

3 Trace the drawing on to tracing paper with an F pencil.

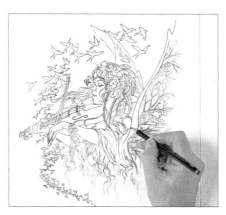

4 Turn the tracing over and go over the lines on the back using a B pencil.

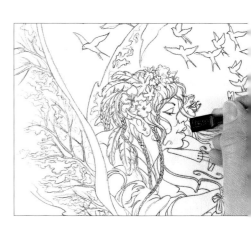

5 Tape the tracing right side up on your watercolour paper, leaving the bottom of the tracing free so that you can lift it to check on the results. Use the flat end of a burnisher or the lid of a ballpoint pen to transfer the image on to the paper.

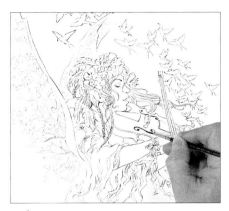

6 Use a no. 1 sable brush and burnt umber to paint the outline.

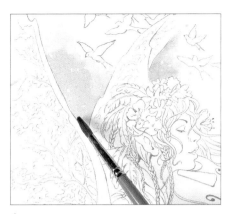

7 Make a thin mix of raw sienna and use a no. 6 brush to flood it into the background. Leave some white showing. Soften the edges with a much weaker mix that is almost pure water.

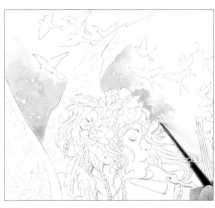

8 Change to a no. 3 brush for more detailed areas.

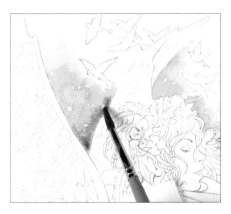

9 Make a thin mix of Indian red and paint it wet in wet around the edges of the wings. Allow to dry.

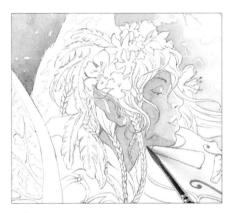

10 For the skin tones, mix burnt sienna with Chinese white and a little raw umber. Add a brushload of the raw sienna background mix. Use the no. 3 brush to paint the face. Add water to the mix for highlighted areas such as the front of the face.

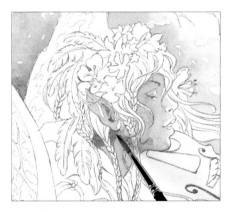

11 Paint the shaded areas under the hair wet in wet using the skin tone mix with burnt umber and a little more burnt sienna added. Blend them in using clear water.

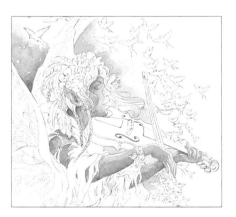

12 Complete all the skin tones in the same way.

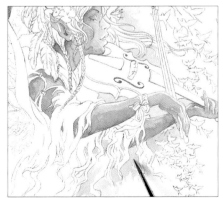

13 Continue painting the background with the raw sienna mix and the no. 3 brush.

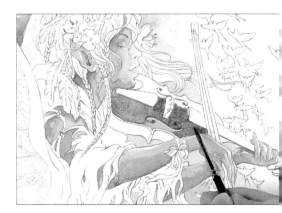

14 Mix Indian red with a little burnt umber and flood it into the violin area.

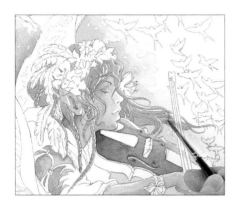

15 Block in the hair with the no. 3 brush and a mix of cadmium orange, raw sienna and Indian red. Leave some areas white for highlights at the front.

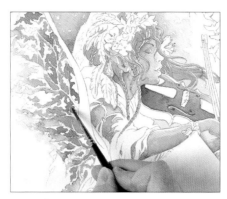

16 Paint in between the outlines on the wing with burnt sienna and the no. 3 brush. Soften the edges with clean water.

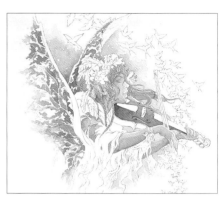

17 Paint the second wing in the same way.

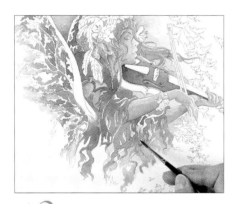

18 Paint the clothes using the same brush and a mix of cadmium orange, raw sienna and cadmium red deep. Add water at the edges to make them less defined.

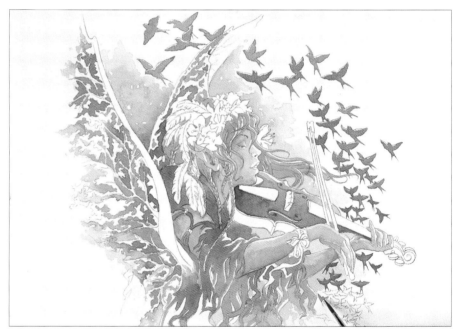

19 Change to the no. 2 sable brush and a thin mix of Indian red to paint the birds. Leave white highlights on the wings where appropriate.

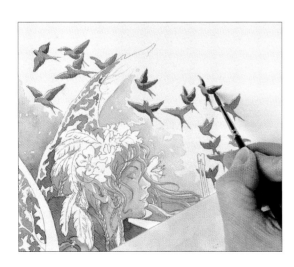

20 Add dioxazine violet to the Indian red mix and run darker lines under the wings and bodies of the birds.

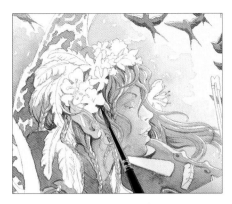

21 Mix cadmium orange with Indian red and dioxazine violet and darken areas of the hair to define it.

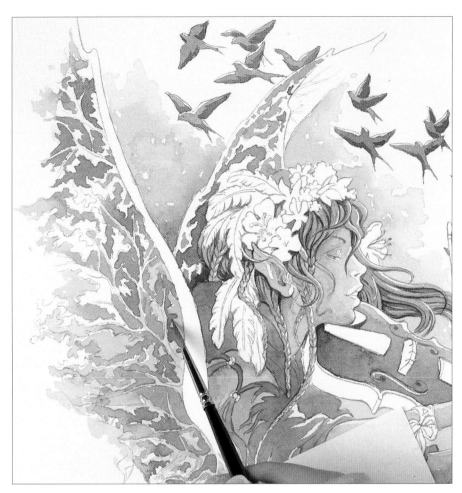

22 Paint the areas left white in the wings with cadmium yellow and a little cadmium orange and the no. 2 brush.

23 Mix burnt sienna, dioxazine violet and cadmium red deep to create a darker tone to model the fairy's clothes. Use a darker mix in the shadow of the violin.

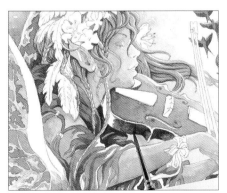

24 Paint the side of the violin with a mix of burnt umber and dioxazine violet. Add burnt sienna for the lighter areas, painting wet in wet. Leave a white highlight on the

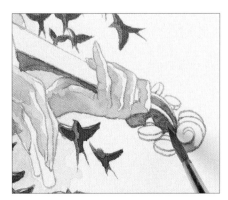

25 Paint the end of the violin with burnt sienna, leaving some white highlight for modelling. Allow to dry.

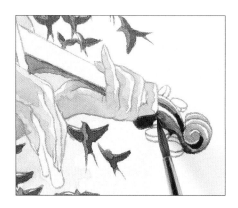

26 Add dioxazine violet to the burnt sienna mix to paint in the darker tones wet on dry. Soften any hard edges with clean water.

27 Paint the darker part of the neck of the violin using a mix of burnt umber and dioxazine violet.

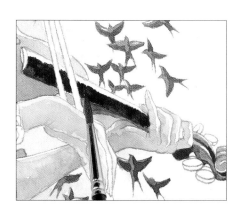

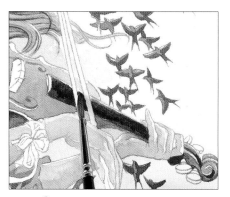

28 Run in burnt sienna wet in wet for the lighter top part of the violin's neck. Leave a tiny white highlight at the top edge. Repeat steps 27 and 28 to paint the remaining parts of the violin.

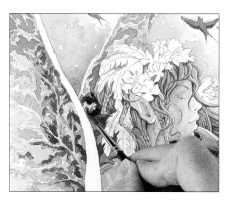

29 Mix burnt sienna and dioxazine violet to paint shadow under the foldover of the wing. Also shadow the back wing to accentuate the headdress which will be painted later.

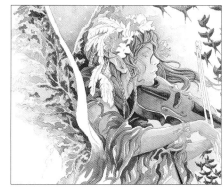

30 Paint some of the flowers in the fairy's hair, the ribbon on her wrist and the rings in her clothes in a mix of cadmium yellow and cadmium orange.

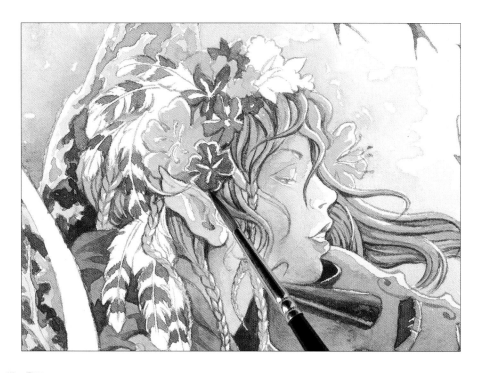

31 Paint the red flowers and parts of the feathers with a mix of cadmium red deep with a little Indian red. Leave some areas white. Water down the mix to paint the fairy's lips, leaving highlights at the front.

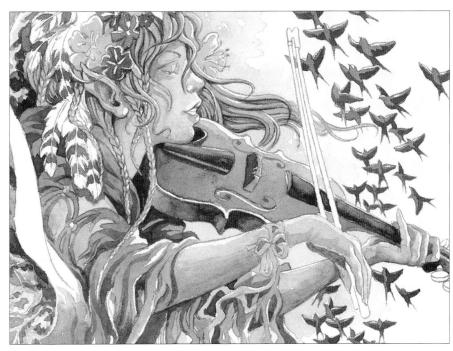

32 Add definition to the face and the ear using a mix of burnt sienna and a little burnt umber for shadow. Define the nostril, colour beneath the nose and add darker tones in the ear and under the hair.

33 Use the same mix to add shadows to the arms and hands, under the dress straps and the feathers.

TIP

Shadows help to create a three-dimensional look. By painting the shadows of the garment further away from the fabric, you can make the fabric look raised away from the skin.

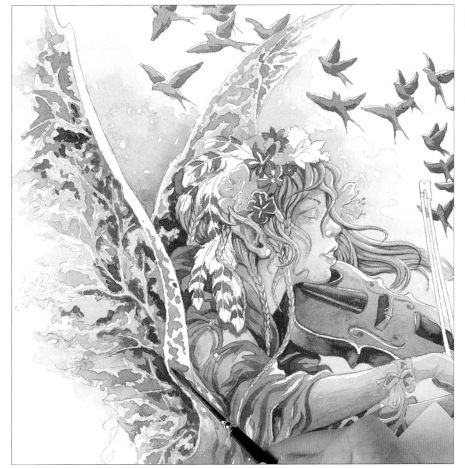

34 Paint the wing foldover with burnt sienna and a touch of burnt umber.

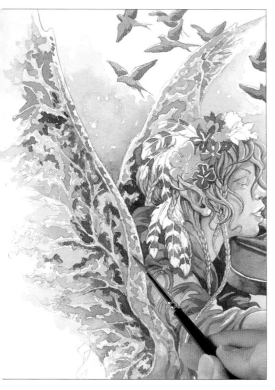

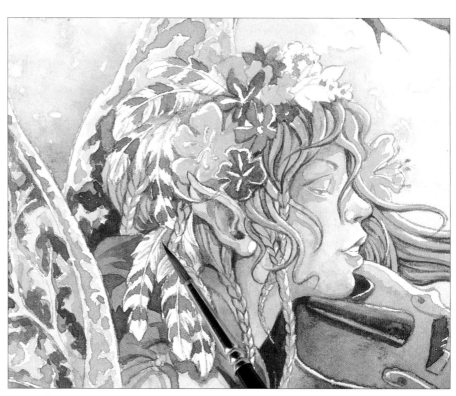

3 5 Add yellow to both wings with a mix of cadmium yellow and a touch of cadmium orange. Apply the paint gently, allowing some white to show through.

3 6 Mix Chinese white with Payne's gray and dioxazine violet to shadow the feathers and the white flowers using the no. 2 brush.

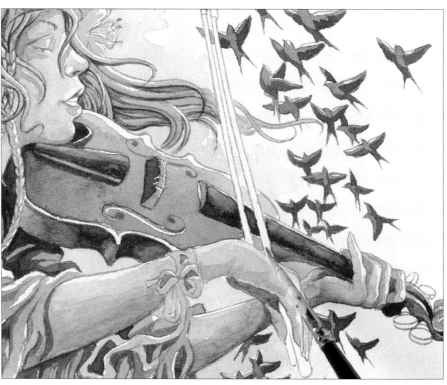

3 7 Make a weak mix of cadmium orange, raw sienna and cadmium red deep and use the no. 6 brush to fade the clothes off at the bottom. Soften the edges with water.

3 8 Use masking fluid and an old no. 1 brush to mask the highlight on the bow, which is on the inside of the right-hand part of the bow.

39 Paint the right-hand side of the bow, over the masking fluid, with burnt umber and dioxazine violet and the no. 1 brush. Use a drier mix to define the details on the violin. Allow to dry and remove the masking fluid with a soft eraser. Then paint the left-hand side of the bow with raw sienna and a touch of burnt sienna.

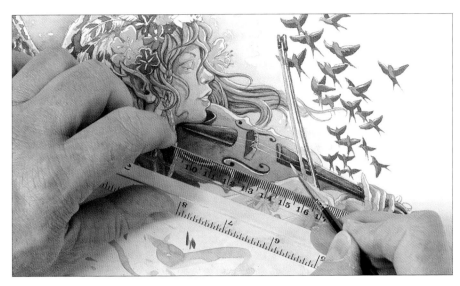

40 Use a creamy mix of permanent white gouache to suggest the violin strings by brush ruling as shown. Place your fingers behind the ruler to support it at an angle of forty-five degrees, and use your thumb to press the bottom of the ruler into the board. Paint the lines using a no. 1 brush.

41 Use permanent mauve and the no. 2 brush to define the brow around the fairy's eye. Add water to soften the edges. Add lamp black to the permanent mauve mix and touch in the eyelashes and the eyebrow.

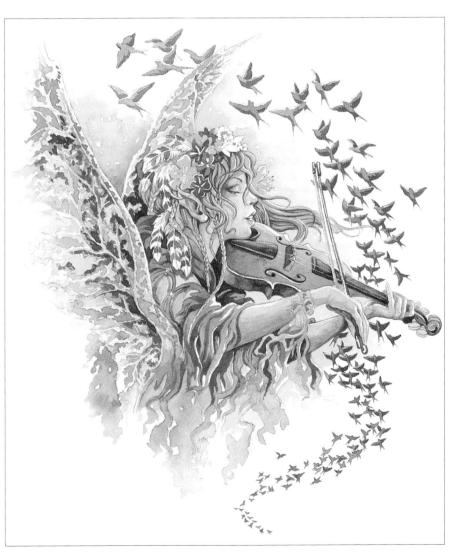

The painting after step 41.

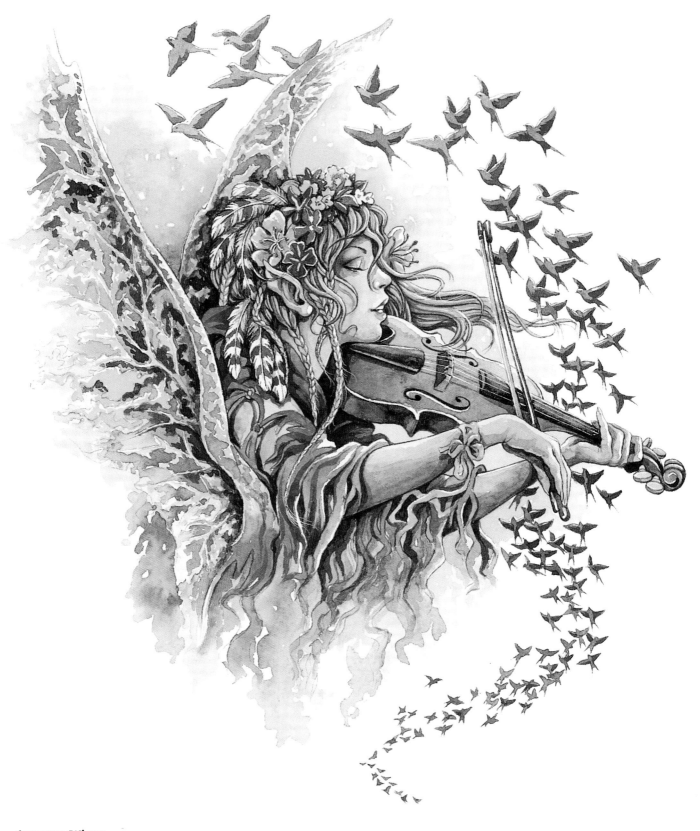

Autumn Wings

The finished painting. When the main areas of colour are completed and most of the detail put in place, it is time to re-evaluate the composition. In this case it was felt that the painting needed strengthening and to this end the detail in the hair and around the head and arms was clarified with a mix of Vandyke brown and dioxazine violet using a no. 2 sable brush. At this stage shadows of burnt umber were added beneath the violin strings using the brush rule method. Extra cadmium red has been added to some flowers. Finally, permanent white gouache has been used for the highlighting.

Lily Dancer

A fairy who is completely formed from water. A natural exhibitionist, she can be spotted dancing on lily pads in ponds and streams in the country. Although happy to be admired from a distance, should she sense danger, she will simply dissolve back into a pool of water, never to be seen again. In contrast to Autumn Wings (opposite), cool colours were chosen here. A mix of intense blue and Payne's gray (wet on dry) were used for the fairy. Small amounts of mauve and black were used for defining the recesses and modelling. Using a no. 2 sable, brush strokes of gamboge hue, intense green and mauve were added to the figure to lift the colours and avoid blandness. The subtle use of these colours also provides a link with the lily pad, which uses the same colours. The water is a thin mix of viridian, intense blue and a little Payne's gray.

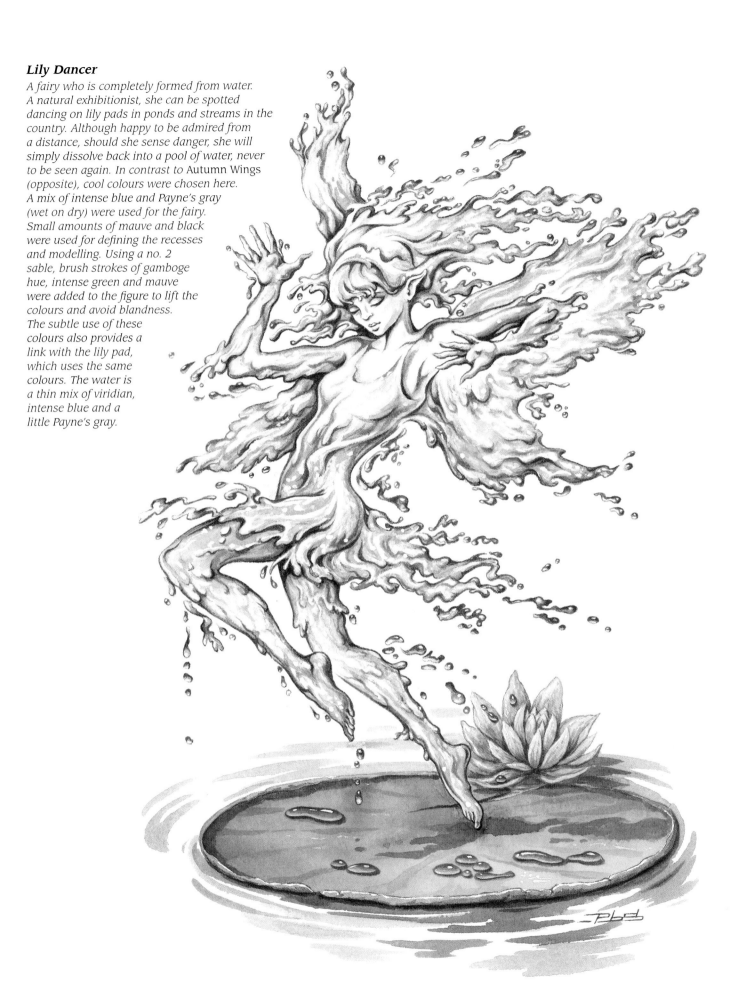

Plant Life

As with the previous project, planning went into the design and colour scheme of this piece. I decided that the composition should have a decorative and slightly feminine feel to it, loosely based on the colour of the flower, a photograph of which was used as reference. Delicate pinks, mauves and blues were decided upon to achieve this look.

YOU WILL NEED

Watercolour paper
Tracing paper
Printer paper
Ballpoint pen
F and B pencils
Burnishing tool or ballpoint pen lid
Masking fluid
Soft eraser
Kitchen paper
Brushes:
Old no. 2, no. 1 and no. 2 sable and no. 6 round
Paints:
Burnt umber, cobalt violet, ultramarine, permanent mauve, burnt sienna, Chinese white, raw sienna, Indian red, permanent rose, rose madder, new gamboge, lamp black, cadmium red deep and dioxazine violet

1 Sketch the picture in pencil, blocking out the main shapes of the composition.

2 Draw the scene with all its detail using a ballpoint pen on ordinary printer paper.

3 Trace the drawing on to tracing paper using an F pencil.

4 Turn the tracing over and go over all the lines on the back using a B pencil.

5 Transfer the image on to the watercolour paper by going over the tracing with a burnishing tool or the lid of a ballpoint pen. Paint in the outline in burnt umber, using a no. 1 brush.

6 Before painting the background, mask the edges of the main image using an old no. 2 brush and masking fluid. Make a watery mix of cobalt violet and paint in the background with a no. 6 brush.

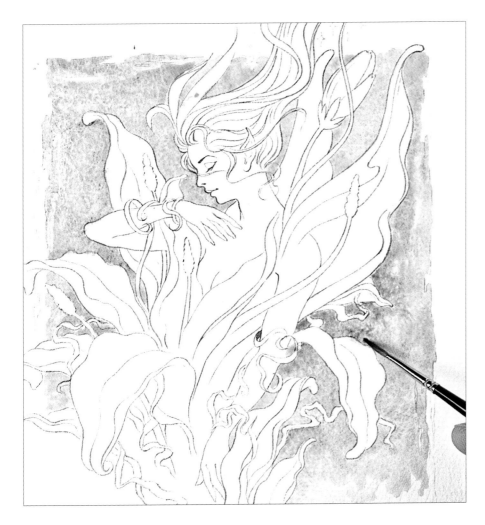

7 Drop in ultramarine wet in wet using a no. 2 brush. Add a little permanent mauve in the same way.

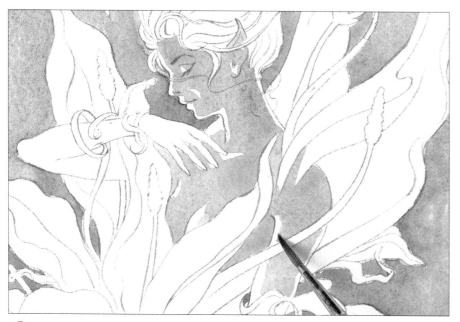

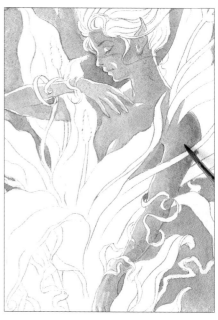

8 Use a soft eraser to remove the masking fluid. Make a very watery skin tone mix from burnt sienna, Chinese white, a little raw sienna and cobalt violet. Use a no. 2 brush to flood colour into the face. Leave a white highlight down the front of the face. If the highlights are too sharp, use a watered down version of the same mix to soften the edges.

9 Painting wet in wet, use a mix of cobalt violet and Indian red to define the shaded areas. Allow the painting to dry.

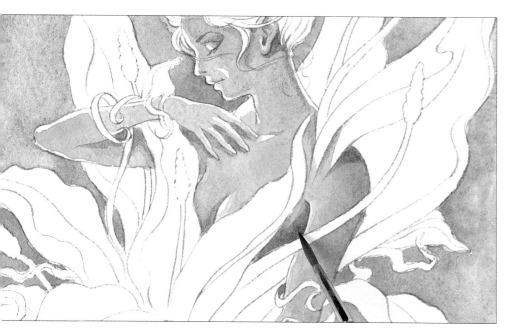

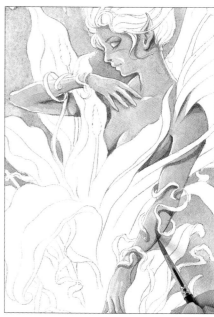

10 Now painting wet on dry, loosely define the recesses and shadowed areas using the darker mix with permanent mauve added. Remember that the light source is on the left of the painting.

11 Further darken and define some areas. Add ultramarine to cobalt violet and Indian red and shade the cleavage and underarms, painting wet on dry with the no. 2 brush. Paint the nostril and the drop shadows under the plant tendrils.

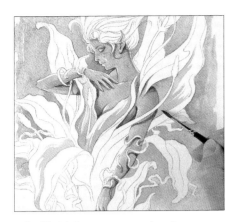

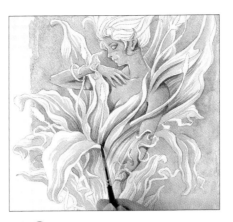

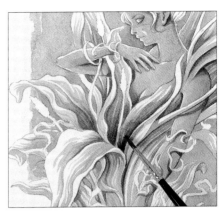

12 Make a watery mix of permanent rose and permanent mauve for the lily, and run it in towards the centre of the flower. Paint the petal that forms the fairy's wing. Soften the edges with water.

13 When the pink paint has dried, add ultramarine to the mix and paint on the darker areas of the lily using a no. 2 brush.

14 Painting wet on dry, overlay rose madder on some of the bluer areas of the flower.

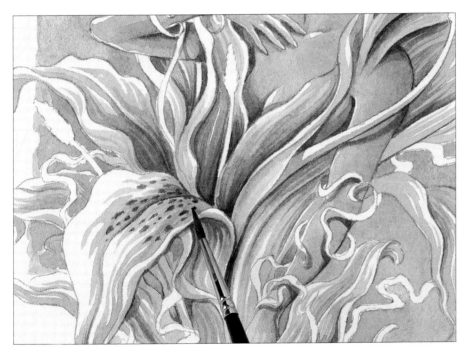

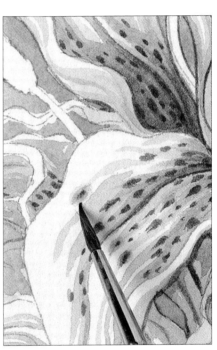

15 Mix ultramarine and permanent mauve to paint the lily's spots. Paint them in an irregular pattern, in various sizes.

16 Make a very watery mix of permanent rose, get rid of the excess on kitchen paper and with an almost dry brush, go over some of the spots to soften and 'smudge' them.

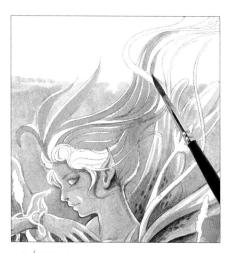

17 Paint the petal headdress and the hair with burnt sienna, a little cobalt violet and a little Indian red. Leave a white highlight at the front. Allow to dry.

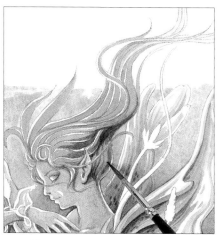

18 Use a stronger mix of the same colours with a little ultramarine added, to paint the darker areas of the hair. Darken behind the ear to make it stand out.

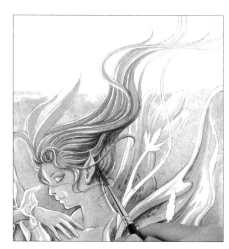

19 Make a strong mix of ultramarine, permanent mauve and a little Indian red and use a no. 1 brush to further define the hair.

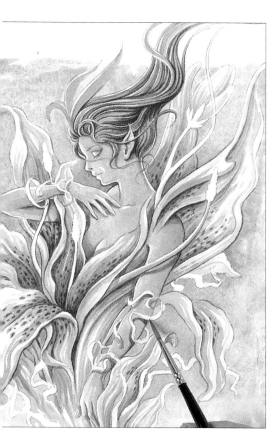

20 Make a pale mix of Chinese white with new gamboge and paint the edge of some petals, the white highlights in the hair and the tendrils around the fairy's arm.

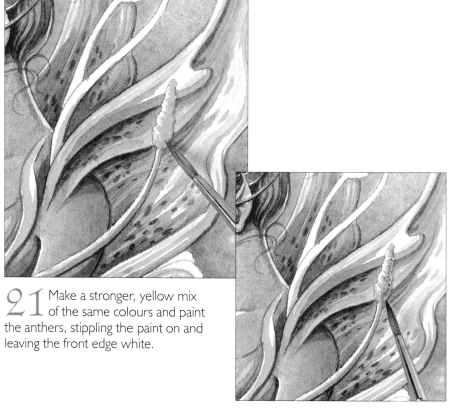

21 Make a stronger, yellow mix of the same colours and paint the anthers, stippling the paint on and leaving the front edge white.

22 Add permanent mauve to the yellow mix and stipple on texture to suggest pollen.

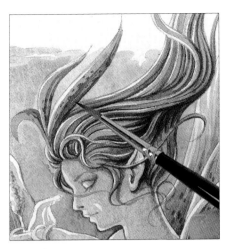

23 Use a mix of permanent mauve and Indian red to darken the shadowed parts of the fairy's headdress. Paint the spots with a stronger mix of the same colours.

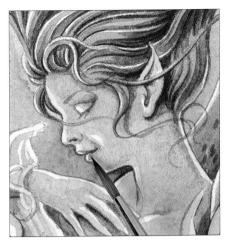

24 Add details to the face using the skin tone mix of burnt sienna, Chinese white, raw sienna and cobalt violet and the no. 2 brush. Touch in detail around the base of the nose. Add a little permanent rose and a little more cobalt violet and paint the lips, leaving a white highlight at the front. Add permanent mauve and define between the lips.

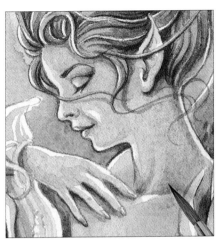

25 Define the eyelid with a mix of permanent mauve and ultramarine, and add a shadow under the hair that crosses the face. Mix lamp black with permanent mauve and use the no. 1 brush to paint the lashes and the eyebrow. Shape the neck with the no. 2 brush and the darker skin tone mix.

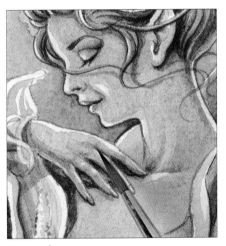

26 Use the same darker skin tone mix to shape the hand and put a stronger shadow underneath it. Define the fingernails.

27 Paint rough star shapes around the fairy's flying hair using a wet mix of cobalt violet. Soften the edges with water. Make a weak mix of new gamboge and Chinese white and do the same again. Allow the shapes to dry. Mix cobalt violet with permanent mauve and touch in little stars in the purple shapes. Finally mix new gamboge with a touch of cadmium red deep and touch in stars within the yellow shapes.

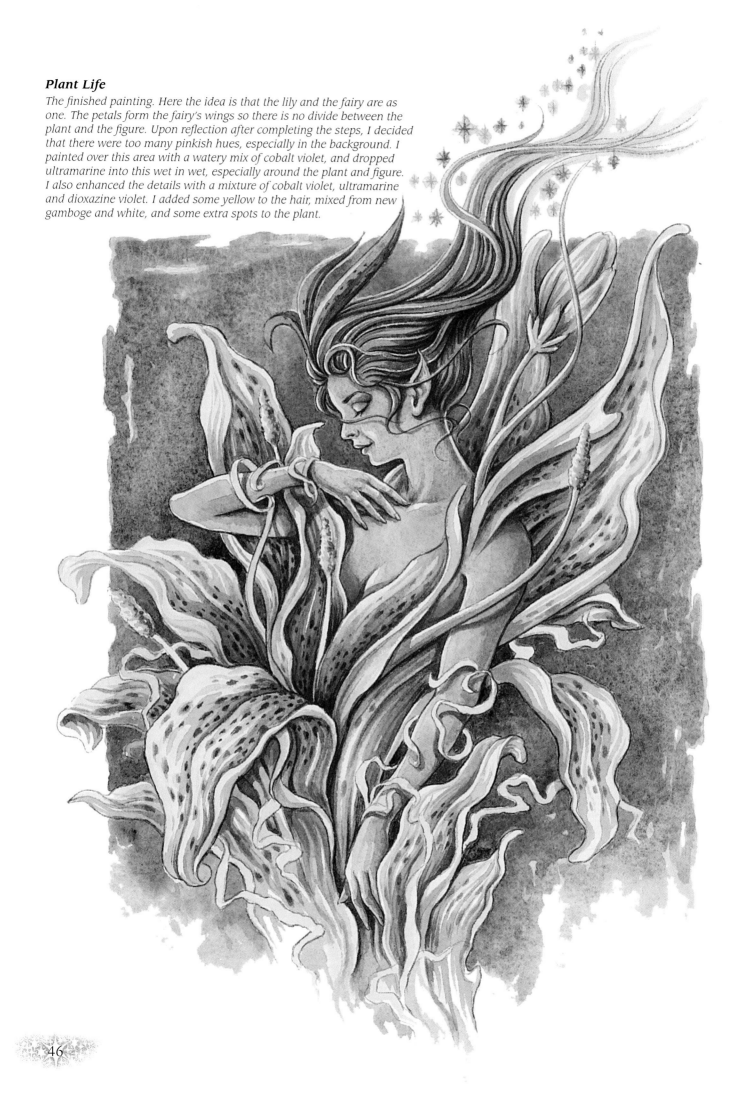

Plant Life

The finished painting. Here the idea is that the lily and the fairy are as one. The petals form the fairy's wings so there is no divide between the plant and the figure. Upon reflection after completing the steps, I decided that there were too many pinkish hues, especially in the background. I painted over this area with a watery mix of cobalt violet, and dropped ultramarine into this wet in wet, especially around the plant and figure. I also enhanced the details with a mixture of cobalt violet, ultramarine and dioxazine violet. I added some yellow to the hair, mixed from new gamboge and white, and some extra spots to the plant.

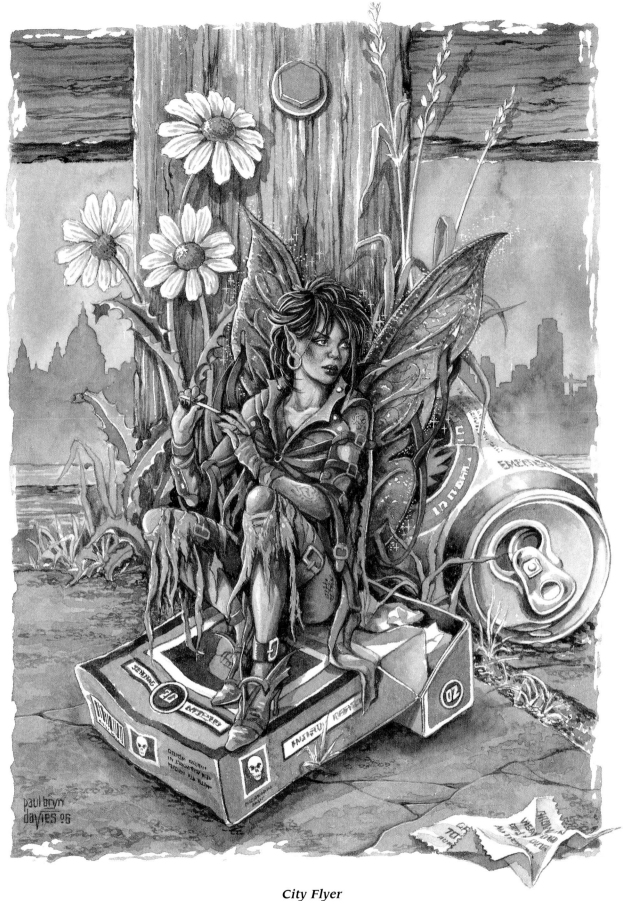

City Flyer

This urban beauty has taken a break from her busy day to stop and file her nails. As mentioned before, I do not feel it necessary for all fairies to be placed in a rural environment and so, in complete contrast to Plant Life shown opposite, this fairy is placed in a downtown area of the city. The palette of Payne's gray, black and white was chosen for the background to denote a dull, grey day and to create a bland backdrop for the fairy. The colours used for the fairy are dioxazine violet, cadmium red deep, burnt sienna, Chinese white, ivory black and permanent white gouache for highlighting. This colour scheme ensures the fairy becomes the main focus of the composition as the eye is immediately drawn to her.

Index

For a complete list of all our books, see www.searchpress.com

- A huge selection of art and craft books, available from all good book shops and art and craft suppliers
- Clear instructions, many in step-by-step format
- All projects are tried and tested
- Full colour throughout
- Perfect for the enthusiast and the specialist alike
- Free colour catalogue
- Friendly, fast, efficient service
- Customers come back to us again and again

For the latest information on our books, or to order a free catalogue, visit our website:

www.searchpress.com

Alternatively, write to us:

SEARCH PRESS LTD,
Wellwood, North Farm Road,
Tunbridge Wells, Kent,
TN2 3DR

Tel: (01892) 510850
Fax: (01892) 515903
E-mail: sales@searchpress.com

Or if resident in the USA to:

SEARCH PRESS USA,
1338 Ross Street,
Petaluma, CA 94954

Tel: (707) 762 3362
24-hour fax:
(707) 762 0335
E-mail:
sales@searchpressusa.com
www.searchpressusa.com

Or if resident in Australia to:

SEARCH PRESS AUSTRALIA,
A division of Keith Ainsworth
Pty Ltd,
Unit 6, 88 Batt Street, Penrith,
2750, NSW

Tel: 047 32 3411
Fax: 047 21 8259
E-mail:
sales@searchpress.com.au
www.gurooz.com.au